CONTENTS

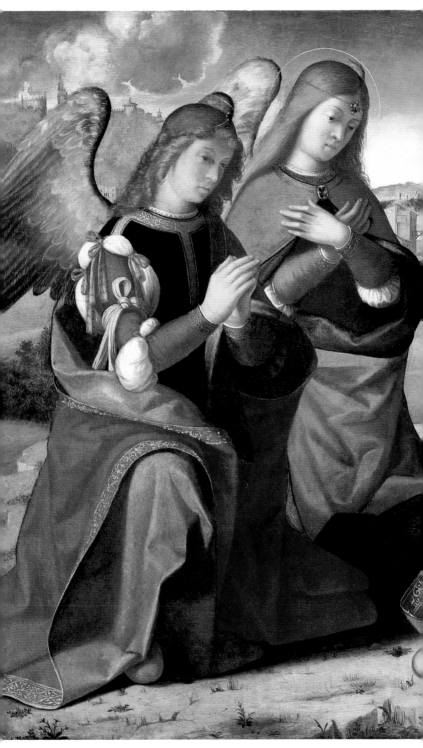

POCKET GUIDES

ANGELS

Erika Langmuir

NATIONAL GALLERY PUBLICATIONS LONDON

DISTRIBUTED BY YALE UNIVERSITY PRESS

This publication is supported by
The Robert Gavron Charitable Trust

THE POCKET GUIDES SERIES

Allegory, Erika Langmuir
Conservation of Paintings, David Bomford
Faces, Alexander Sturgis
Flowers and Fruit, Celia Fisher
Frames, Nicholas Penny
Impressionism, Kathleen Adler
Landscapes, Erika Langmuir

FORTHCOMING TITLES
Colour, David Bomford and Ashok Roy
Saints, Nicholas Penny

Front cover and title page: Guido Reni, *The Coronation of the Virgin,*
see 12 and 14.

First published in Great Britain in 1999 by
National Gallery Publications Limited
St Vincent House, 30 Orange Street, London, WC2H 7HH

ISBN 1 85709 249 X

525287

British Library Cataloguing-in-Publication Data.
A catalogue record is available from the British Library.
Library of Congress Catalog Card Number: 97-70235

Edited by Caroline Bugler
Designed by Gillian Greenwood
Printed and bound in Germany by Passavia Druckservice GmbH, Passau

FOREWORD

The National Gallery contains one of the finest collections of European paintings in the world. Open every day free of charge, it is visited each year by millions of people.

We hang the pictures in the Collection by date, to allow those visitors an experience which is virtually unique: they can walk through the story of Western painting as it developed across the whole of Europe from the beginning of the Renaissance to the end of the nineteenth century – from Giotto to Cézanne – and their walk will be mostly among masterpieces.

But if that is a story only the National Gallery can tell, it is by no means the only story. The purpose of this new series of *Pocket Guides* is to explore some of the others – to re-hang the Collection, so to speak, and to allow the reader to take it home in a number of different shapes, and to follow different narratives and themes.

Christian saints, and the angels who bless so many of the earlier works in the Gallery, shed light not only on the meaning of individual pictures but also on the functions of religious art in European society. Colour, that fundamental ingredient of painting, is shown to have a history, both theoretical and physical – and Impressionism, perhaps the most famous and certainly the most popular episode in that history, is revealed to have been less a unified movement than a willingness to experiment with modern materials and novel subject matter.

These are the kind of subjects and questions the *Pocket Guides* address. Their publication, illustrated in full colour, has been made possible by a generous grant from The Robert Gavron Charitable Trust, for which we are most grateful. The pleasures of pictures are inexhaustible, and our hope is that these little books point their readers towards new ones, prompt them to come to the Gallery again and again and accompany them on further voyages of discovery.

Neil MacGregor
DIRECTOR

1. Detail from *The Virgin and Child with Two Angels* attributed to Andrea Previtali c.1512–20.

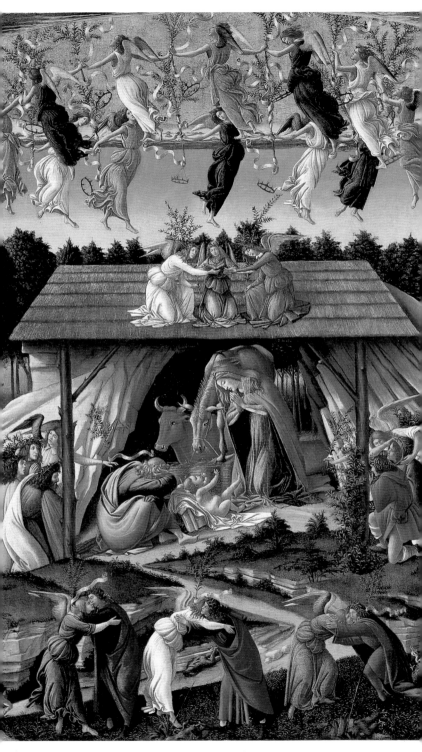

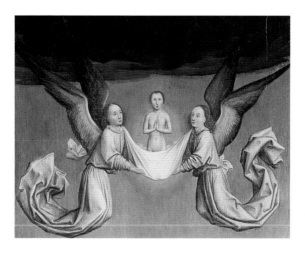

INTRODUCTION

Everyone loves an angel. Sleeping babies are 'good as angels'; a girl may look 'beautiful as an angel'. We say, 'You're an angel!' to a helpful friend. Some 69 per cent of Americans, according to *Time* magazine, believe in the existence of angels. Hundreds of sites on the Internet are said to be dedicated to them. Films are made about them.

Although equivalents may be found in most religions, the angels of Western tradition originate in Scripture. They are familiar, however, even to people who have never read the Bible and have little interest in spiritual matters. This familiarity, I think, comes above all from the frequency with which angels have been pictured in European art, in the 'high' art of the Christian Church, of museums and galleries, and in 'popular' prints or greeting cards. We can imagine angels because we, and generations before us, have seen so many images of them.

In paintings, angelic choirs – like the ancient Greek chorus from which the word 'choir' derives – comment in unison on the main action of the drama, like Botticelli's celestial dancers celebrating the birth of Jesus [2]. At other times, single angels, akin to Shakespeare's one-man chorus, set the scene and directly address the viewer. Some angels play leading roles in the universal story of Salvation. Others are charged with the salvation of individuals: Marmion's angelic couriers deliver the naked soul of the dead Saint Bertin up to God [3]. They are not all,

2. Sandro Botticelli, *'Mystic Nativity'*, 1500.

3. Detail from *The Soul of Saint Bertin carried up to God*, about 1459, by Simon Marmion.

of course, perpetually good: Satan is a fallen angel (see pages 35–41, 73).

While we seldom fail to recognise them, angels in art do not all look the same. They need not be winged [4]. They can wear antique dress, church vestments, secular fashions [6], armour, or nothing at all. We cannot be sure of their sex [5]; they can be children or adults. They may not even have bodies, but appear only as winged heads. While they should not be confused with human saints, real or legendary, they may, like saints, be pictured with haloes (see *Pocket Guide: Saints*).

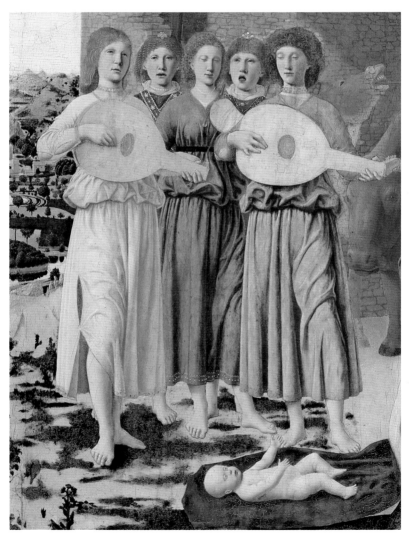

6. Attributed to
Francesco di
Antonio,
*The Virgin and
Child with Six
Angels and Two
Cherubim,*
about 1430.

When we turn from images to texts, we find angels called by a variety of exotic names, from the familiar 'cherubim' and 'seraphim' to the obscure 'thrones' and 'dominations' (pages 28–9). What these terms mean, and how they came into use, is an integral part of the history of angels in Western thought.

Luckily, since we are dealing mainly with pictures and not medieval philosophy, we need not decide whether angels are part body or pure spirit, nor how many can dance on the head of a pin.

I ANGELS
The nature of angels

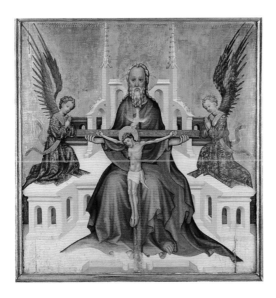

The word 'angel', like its equivalents in most European languages, is derived from the Greek word *angelos*, meaning 'messenger', a translation of the biblical Hebrew *mal'ak*. Angels, as we will see, often act as God's messengers – but that, as Saint Augustine wrote, describes an angel's role, not its nature.

The Bible tells us that angels are spirits, created by God before he created man. They stand between God and man: 'For thou [God] hast made him [man] a little lower than the angels...' (Psalm 8:5).

Angels are, first of all, God's attendants at the court of Heaven. That is how they are frequently described in the Hebrew Bible: 'I saw the Lord sitting on his throne, and all the hosts of heaven standing by him on his right hand and on his left' (1 Kings 22:19).

In obedience to the second of the Ten Commandments – 'Thou shalt not make unto thee any graven image' (Exodus 20:4) – Jews did not depict God. Christian art gradually eroded the prohibition, although it rarely, except in scenes of the Creation, depicted him without reference to Christian dogma. A painting of about 1410 by an unknown Austrian artist [7], the central panel of a dismembered altarpiece, represents the Christian version of the 'throne

7. Austrian School, *The Trinity with Christ Crucified,* about 1410.

11

8. Bartolomé Esteban Murillo, *The Two Trinities* ('The Pedroso Murillo'), about 1675–82.

of mercy' described in the Hebrew Bible (see p 20). God the Father sits enthroned, as befits a ruler and judge, but his justice is tempered by mercy, for he offers up his only Son, crucified for the redemption of man's sins. Father and Son, with the white dove of the Holy Spirit, form the Holy Trinity, the Christian concept of three persons united in one godhead.

On God's 'right hand and on his left' two angels stand in for 'all the hosts of heaven'. Wearing brocade gowns and stoles that recall, without precisely imitating, the liturgical vestments of priests and deacons, they kneel in prayer and sorrowful contemplation, eyes fixed on the broken body of the Saviour. Red, the colour of martyrdom, and green, the colour of life's triumph over death – worn by clergy during the

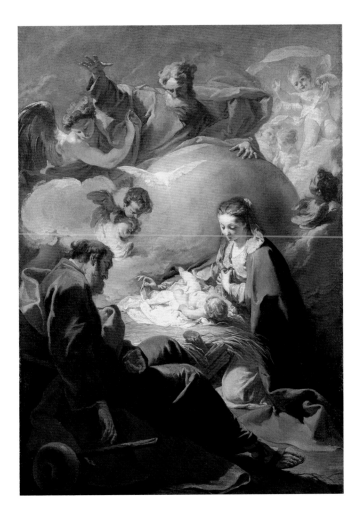

Epiphany season when the birth of Christ is revealed to mankind – play across the figures.

The angels assist at God's sacrifice, like clergy at the altar during mass. We, lower than they, are called upon to model ourselves on their behaviour.

In Murillo's *Two Trinities* [8] and Pittoni's *Nativity with God the Father and the Holy Ghost* [9], angelic hosts tumble about the clouds that divide the celestial from the terrestrial spheres, and dissolve into the radiance which surrounds God the Father, while the Holy Spirit decends from Heaven 'like a dove' – a symbol that first appears in the Gospels' description of Christ's baptism. Some gaze upwards in adoration, others downward with interest and joy, expressing their intermediate nature between God and man.

9. Giovanni Battista Pittoni, *The Nativity with God the Father and the Holy Ghost,* about 1740.

13

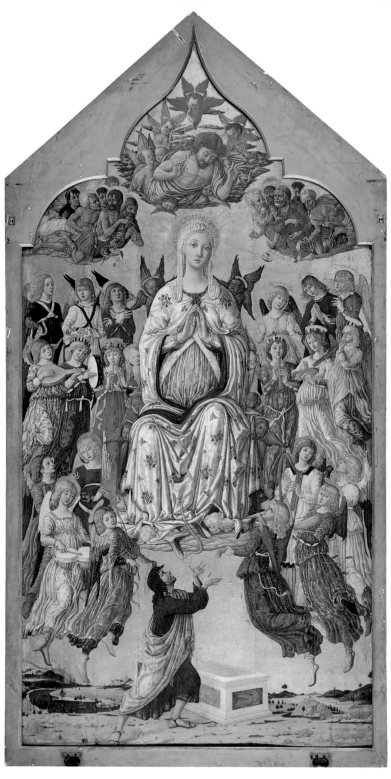

14

Celestial orchestras
and choirs

Praise ye the Lord. Praise God in his sanctuary:
* praise him in the firmament of his power...*
Praise him with the sound of the trumpet: praise
* him with the psaltery and harp.*
Praise him with the timbrel and dance: praise him
* with stringed instruments and organs.*
Praise him upon the loud cymbals: praise him upon
* the high sounding cymbals.*

<div align="right">(Psalm 150)</div>

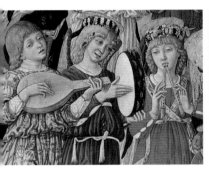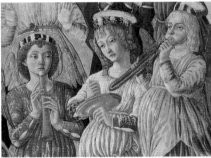

Following the Psalmist's exhortation, angels form celestial orchestras. In Christian art, where they appear from the fifteenth century onward, these ensembles are most often employed to glorify the Virgin Mary. According to tradition, three days after her death Mary was taken bodily up to Heaven, leaving behind her an empty tomb. Although declared a Roman Catholic article of faith only in 1950, the Assumption of the Virgin was for many centuries celebrated as a Church festival, and inspired many works of religious art. In Matteo di Giovanni's large altarpiece [10], Mary is carried high above the earth into the skies, to be received by her Son and jubilant angels. No earthly fifteenth-century group of musicians would have simultaneously performed on all the instruments depicted: pipes and drums, cymbals, tambourines, viols and lutes, a portative organ, a psaltery and a harp. They are played in Paradise partly to convey the lavishness of God's court, but mainly to recall the philosophers' notion of celestial

10. Matteo
di Giovanni,
*The Assumption of
the Virgin,*
probably 1474.

11. Details of 10.

harmony, the music of the spheres in which all dissonance is overcome: an expression, as much mathematical as musical, of the 'order and beatitude' emanating from God.

Once in Heaven, the Virgin was crowned Queen. In this altarpiece [10], her halo is inscribed 'REGINA C[A]ELI LETARE', 'Queen of Heaven, rejoice', the opening words of an Easter antiphon (a hymn sung in alternate parts or responses). Most paintings depict Mary's Coronation solemnised by Christ or by the Trinity, but since she is also REGINA ANGELORUM,

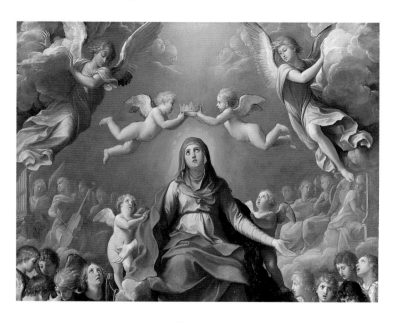

12. Detail from *The Coronation of the Virgin*, by Guido Reni, about 1607.

the Queen of Angels, she may be shown being crowned by the angels themselves [12].

Musical angels surround the Virgin enthroned, whether in heaven or on earth, often holding the infant Jesus. In the small picture attributed to the Master of the Saint Bartholomew Altarpiece [13], some sing from a scroll inscribed '*regi[n]a c[a]eli letare*'. One strews flowers in homage; other flowers grow at the Virgin's feet. The columbine on the left was included because of its resemblance to the dove (*columba* in Latin) of the Holy Spirit, and the flowers on the right, variously identified as pinks, sweet william or corn-flowers, must have been intended to convey some equally apt meaning. (For a discussion of flower symbolism see *Pocket Guide: Flowers and Fruit*.)

Paintings representing Mary's Coronation or showing her seated on a throne are not based literally on the Bible, but they are inspired by it. The 'Song of Songs', a collection of love poems once attributed to King Solomon and for this reason included in the Hebrew Bible, was interpreted by Christians as an allegory of the mystic union of Christ with the human

soul, or of the marriage between Christ and his Church, personified by the Virgin. From the twelfth century, and largely through the sermons of Saint Bernard, Cistercian Abbot of Clairvaux (d.1153), the imagery of Mary's Assumption and Coronation was infused with the ecstatic sentiments of these poems. Christ is sometimes shown holding a book inscribed 'Come my chosen one I shall place thee on my throne', a variant of the refrain, 'Rise up, my love, my fair one and come away' addressed by the Lover to his Bride (for example in Song of Songs 2:10). Other passages from the Song are also paraphrased.

13. Master of the Saint Bartholomew Altarpiece, *The Virgin and Child with Musical Angels*, probably mid-1480s.

In this context, the angels' music assumes an additional meaning: as on earth, it is the food of love, played in courtship and at weddings.

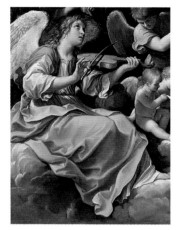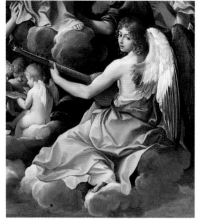

Angelic forms

14 and 15.
Details from
*The Coronation of
the Virgin*
by Guido Reni,
about 1607.

16. Detail of 10.

In the pictures we have looked at so far, angels appear in various forms: as adolescents, youths or chubby infants. In all these guises they are generally shown with wings. They are usually thought to be sexless – yet Guido Reni's *Coronation of the Virgin* seems to distinguish the gender of the two foreground figures: the celestial lutenist on our right [15] is decidedly male, the fiddler on the left is more likely to be female [14]. Perhaps Reni knew the two obscure passages in the Bible that seem to define angels as sexed beings: Genesis 6:4 speaks of the 'sons of God' fathering children; Zechariah 5:9 describes two supernatural women with 'wings like the wings of a stork'. More likely, he was simply aiming for pictorial variety and charm.

Matteo di Giovanni's *Assumption of the Virgin,* on the other hand, depicts Christ borne aloft merely by babies' heads painted red and gold, and Mary by babies' heads in blue and red, each head sprouting three pairs of wings: two above, two on either side and two folded together below [16].

Angels appearing on earth are generally called 'men' in the Hebrew Bible, as in the story of Abraham, who 'lifted up his eyes and looked, and, lo, three men stood by him' (Genesis 18:2); he 'entertained angels unaware.' (Saint Paul's Epistle to the Hebrews 13:1). These angels cannot have looked like women or children, much less like disembodied heads, nor can they have been winged. What, then, inspired Matteo's imagery?

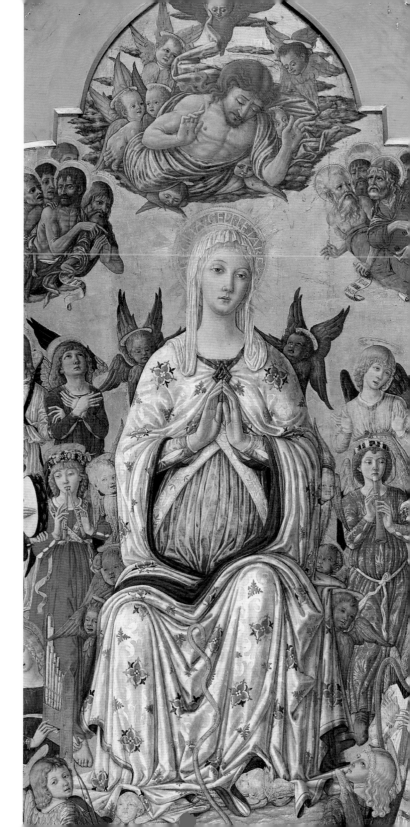

In a number of places, the Bible mentions 'cherubim'. The Hebrew word *k'rubim* derives from the name of Babylonian deities of lower order who mediate between men and the higher gods. They are represented in sculpture as winged giants with human heads and the bodies of lions or bulls; the British Museum has some imposing examples which once flanked the entrances of temples and palaces. Their presence in the Bible may reflect the influence of the Israelites' captivity in Babylon. After God drove out Adam and Eve from Paradise, we are told in Genesis 3:24,'he placed at the east of the garden of Eden Cherubims, and a flaming sword which turned every way, to keep the way of the tree of life.'

Besides guarding God's domain, the cherubim also carried him aloft: 'The Lord reigneth: let the people tremble: he sitteth between the cherubims', sings the Psalmist (Psalm 98:1). The notion is elaborated in the directions for making the cover of the Ark of the Covenant, which formed God's throne:

> *And thou shalt make a mercy seat of pure gold ... And thou shalt make two cherubim of gold ... in the two ends of the mercy seat ... And the cherubim shall stretch forth their wings, and their faces shall look one to another; toward the mercy seat shall the faces of the cherubim be.*
>
> (Exodus 25:17–20)

Making use of the cherubim's wings, God also 'rode upon a cherub, and did fly: and he was seen upon the wings of the wind.' (2 Samuel 22:11; Psalm 18:10).

Related to the winged cherubim are the seraphim:

> *I saw also the Lord sitting upon a throne, high and lifted up, and his train filled the temple.*
> *Above it stood the seraphims; each one had six wings; with twain he covered his face, and with twain he covered his feet, and with twain he did fly. And one cried unto another, and said, Holy, holy, holy, is the Lord of hosts: the whole earth is full of his glory.*
> (Isaiah 6:2–3)

The Hebrew word *s'raphim* originally meant 'burning ones' and is elsewhere translated as 'fiery flying serpents' (for example in Isaiah 30:6). Perhaps the desire to avoid giving cherubim and seraphim the

bodies of lower animals, or Isaiah's description of seraphim covering their feet with their wings, inspired artists to picture both cherubim and seraphim as winged, disembodied human heads.

17. Detail from *The Baptism of Christ* by Giovanni di Paolo, probably about 1453.

I confess that, in all the years I've been looking at Matteo di Giovanni's *Assumption* altarpiece [10], I've only now noticed the exorbitant claims which it makes for the Virgin. In the Bible it is God alone who is borne aloft by seraphim and cherubim, but here they form Mary's airborne throne, tucked in between her and her escort of musical angels [16].

Nowhere in the Bible does it say that the solemn cherubim and the fiery seraphim resemble infants, with or without bodies, or that naked babies flutter about and serenade God. Yet, as we can see in the examples illustrated here and in myriad others from the fifteenth century onwards, these conventions became extremely popular with painters.

For the reason why, we must look not in Scripture, but in artistic tradition. From about 400 BC Eros, the Greek god of love, and his companions the Erotes, had regressed in age and appearance from winged youth to winged babyhood becoming the plump naked cupids and amoretti familiar to us on Valentine's Day cards. The train of Bacchus, the Roman god of wine, was also enlivened by bibulous

PUTTI AND PAGAN GODDESSES

little helpers, precocious infants gathering or press-
ing grapes [18]. These *putti*, as they are known from
the Italian word *putto* (boy), teem on ancient stone
coffins as well as in secular decoration, since Bacchus
and Eros were both associated with the rapture of the
soul and with the afterlife.

Early Christian art seldom depicted angels, only
doing so when required by the narrative. If they
appeared at all before the fourth century, they were
shown as wingless men. After Christianity became the
state religion of the Roman Empire in 324, they
assumed the triumphant form of the winged Graeco-
Roman goddesses of Victory and of Fame, who carried
the illustrious dead away on tireless wings. In 787,
the second Council of the Church at Nicaea affirmed
that it was lawful to represent angels in pictures, and
as their images proliferated through the Middle
Ages, this once pagan convention became the norm.
Something of it still clings to Matteo di Giovanni's
fifteenth-century musical angels [19]. Although in
face, coiffure and body type they appear as idealised
young men of the period, their tunics are modelled on
a contemporary version of ancient female dress – as
worn by Botticelli's nymphs, for example, or by
Gherardo di Giovanni del Fora's Chastity [20].

22

With the Renaissance revival of interest in all aspects of Graeco-Roman art, the *putto* also returned to favour. Painters and sculptors began to vie with each other and with the ancients to picture soft, dimpled bodies in action, with none of the harsh 'dryness' associated with the early study of anatomy. Angelic babies gave the German Master of the Saint Bartholomew Altarpiece a chance to show off, within a native Gothic context, his familiarity with the new Italianate style [13]. Raphael made his angels translucent, suffused with celestial light. Murillo's 'vaporous'

19. Detail of 10.

20. Detail from *The Combat of Love and Chastity* by Gherardo di Giovanni del Fora, probably 1475–1500.

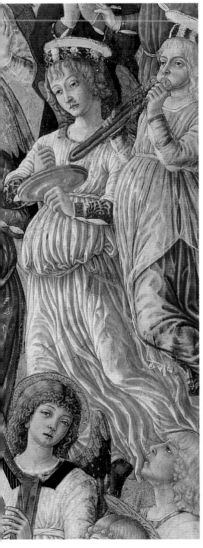

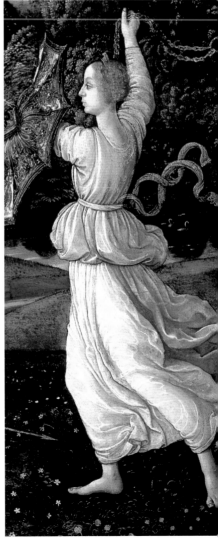

21. Detail of 9.

22. Detail of 8.

baby angels [22] are the culmination of the type and have influenced religious art, high and low, to this day [21]. Baby angels frolic more comfortably, and amusingly, among the clouds than adults, and more of them can be crowded into an image without compromising the consistency of the figures' scale (see the awkward diminution of the three half-length grown-up angels singing behind the Virgin's throne in the little painting by the Master of the Saint Bartholomew Altarpiece [13].

Appealing to artists, naked baby angels also beguiled their viewers, presenting the very picture of innocence and grace; the Virgin Mary naturally welcomed them as playmates for her baby son. When infant mortality was high, images of happy babies gambolling in heaven helped to console bereaved parents, sustaining the popular but heretical belief that angels are the ascended souls of infants who die in a state of grace.

In seventeenth- and eighteenth-century family portraits, dead babies are often pictorially confused with baby angels, smiling down from cloudlets upon their surviving relations. Along with the Baby Jesus himself, childlike angels served as example and exhortation to children – as they still do in many Catholic homes.

The pictorial convention of *putti* angels and infant cherubim and seraphim has left its mark on language, even in those countries which have by and large rejected the pictures themselves. It is not Scripture we have in mind when we call someone 'cherubic', and refer to 'seraphic' smiles.

Multiplying angels

From about 300 BC to the first century AD, many new words were added to those already in use to define the spirits mediating between God and man. This was at first caused by the translation of the Bible into Greek for the use of the Hellenised Jews of Alexandria. Where the Hebrew mentioned the Lord's 'armies' or 'hosts', the Greek version used *dunameis*, 'powers'. The word was taken to mean a kind of angel different from 'cherubim', 'seraphim' or even 'angels' (which, as noted above, was originally merely a translation of 'messengers').

In these centuries of religious ferment, new texts were also written as appendices to the Bible. Those which were not accepted as scriptural are called 'apocryphal', from the Greek word for 'things hidden away', although some of the texts defined as apocryphal by Jews and Protestants are considered by Catholics to be part of the Bible. In all these late biblical and pseudo-biblical writings, God was no longer said to communicate directly with humanity as he had done in Genesis or Exodus; he now made his will known through angels. As the angels' importance grew, so the terms defining them multiplied, especially through translations of the new texts into the many languages spoken by the dispersed Jewish population. Like the Greek *dunameis*, each new term was understood to mean a different category of angel. This proliferation of angelic categories continued in the New Testament, most noticeably in Saint Paul's letters to Christian communities. Thus the late texts of the Hebrew Bible, the apocryphal literature and the Epistles of Saint Paul enriched the vocabulary of angelic types and, subsequently, the imagery of angels in Christian art.

The most important of these 'new' angels were the archangels, from the Greek for 'chief angels' or 'angels of high rank'. Two – Michael and Gabriel – are named in the Book of Daniel, and one – Raphael – in the Book of Tobit, scriptural for Catholics but apocryphal for Jews and Protestants, where it is also said that there were seven archangels in all, standing 'ever ready to enter the presence of the glory of the Lord' (Tobit 12:15). Michael, Gabriel and Raphael, the most

precisely characterised and the most frequently represented archangels, to whom Christian tradition often accords the title of 'saint', will be discussed more fully on pages 35–66. The remaining four archangels, named in other apocryphal texts, are more rarely depicted in art and do not figure in the Gallery's Collection.

To 'angels', 'cherubim', 'seraphim', 'powers' and 'archangels', apocryphal sources also added 'dominions' or 'dominations', 'principalities', 'forces', and 'thrones'. These different kinds of angelic spirits were not at this stage precisely described, but all were said to stand in worship before God or sing hymns to him.

SAINT PAUL

Saint Paul (died around 64 AD) was a Greek-speaking Jew and Roman citizen, originally trained as a rabbi. His grounding in the Jewish Scriptures and Apocrypha led him to interpret Christian texts and theology in the light of these earlier sources. In so doing, he decisively influenced the formation of the Christian tradition which distinguishes nine different ranks or choirs of angels.

23. Detail of Saint Paul from *Saints Peter and Paul* by Carlo Crivelli, probably 1470s.

In an early letter written to the converts he had made in Greece, (1 Thessalonians 4:16), Paul identifies the angels with trumpets, who herald the Second Coming of Christ in the New Testament Book of Revelation (Revelation 8–11), with the archangels mentioned in the Book of Tobit.

In an even more influential pastoral letter to the Christians of Colossae in Roman Asia, Paul recalls the Psalmist's definition of angels as spirits created by God, in order to assert the divinity of Christ,

Who is the image of the invisible God, the firstborn of every creature:
For by him were all things created, that are in heaven, and that are in earth, visible and invisible, whether they be thrones, or dominions, or principalities, or powers: all things were created by him, and for him...

(Colossians 1:16–17, dated to 61–3 AD)

24. Detail of 25.

In the Epistle to the Ephesians, Paul describes Christ risen from the dead and set at God's right hand, 'Far above all principality, and power, and might, and dominion, and every name that is named, not only in this world, but also in that which is to come.' (Ephesians 1:21)

In this letter, a single Hebrew word expressing military strength is translated by Paul into two separate Greek words. These in turn become the two Latin words for power and might – *potestates* and *virtutes* – which in English are translated as 'powers' and, in a strange use of the word, 'virtues'.

With these five groups of spirits – 'thrones', 'dominions', 'principalities', 'powers', 'virtues' – added to the older 'angels', 'archangels', 'cherubim' and 'seraphim', Paul bequeathed to the Christian world the notion of nine ranks or choirs of created spirits, lower than God but higher than men, distinctive in station, duties and appearance.

It only remained to describe those who had never been described, and put them all in order.

28

Many tried. The person who did the job most convincingly was a late fifth-century Greek, Dionysius. Since he pretended to be writing in the lifetime of the Apostles, he was mistakenly identified with the first-century Athenian judge, Dionysius (or Denis) the Areopagite, converted to Christianity by Saint Paul (Acts of the Apostles 17:34). Dionysius's treatise *On the Celestial Hierarchies* – inspired by Paul's Epistles, by fifth-century Greek philosophy and by the hierarchic organisation of the Byzantine imperial court – was supposed to record Paul's account of a vision of Heaven he had experienced.

The book was brought to Rome by Greek monks fleeing the Islamic incursions of the eighth century, and from Rome was sent to France. There, in about 860, it was translated into Latin by a philosopher at the court of Charles the Bald. From this time the Greek Dionysius/Denis was popularly confused with Saint Denis, a holy martyr of Gaul and first bishop of Paris. In Latin versions his treatise became a major source of inspiration throughout medieval Europe. While its system was never made a matter of faith by the Church, it was accepted by the poet Dante, the great Dominican philosopher Saint Thomas Aquinas, and Jacobus de Voragine (d. 1298), author of the *Golden Legend,* the most important compilation of saints' lives. Directly and through the writings of these authors the pseudo-Areopagite's ordering of the celestial court influenced the imagery of Heaven, its authenticity unquestioned until the fifteenth century and disowned only in the nineteenth.

According to Dionysius, the nine angelic choirs are divided into three hierarchies. Flanking Christ's throne is the topmost hierarchy of *counsellors*, comprising seraphim, coloured red to signify Divine Love, cherubim in blue symbolising Divine Wisdom, and yellow thrones.

The hierarchy beneath is that of the *governors* of the stars and the elements. They include the dominions (or dominations), virtues and powers. Dressed predominantly in blue, they receive divine illumination from the first hierarchy and communicate it to the third. Both *counsellors* and *governors* remain aloof from mortals.

The third and lowest hierarchy is that of the *messengers*, who intervene in the affairs of human-kind. They are the principalities (or princedoms), the archangels, and the angels – a generic term as well as the name of the ninth choir.

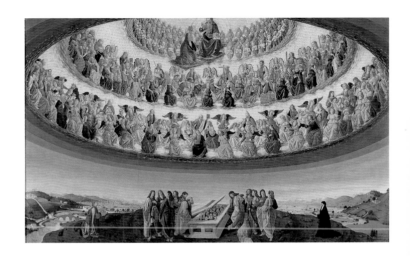

Dionysius's system inspired the nine groups of angels ranged on either side of the central scene in Lorenzo Costa's mystic *Adoration of the Shepherds*, to which other angels bring the Instruments of Christ's Passion [25]. It is even more clearly reflected in Botticini's large panel of the *Assumption of the Virgin* [26], although the artist, under the influence of a contemporary text written by his patron, introduced prophets and saints into the angels' lower ranks [27].

26. Francesco Botticini, *The Assumption of the Virgin*, probably about 1475–6.

27. Detail of 26.

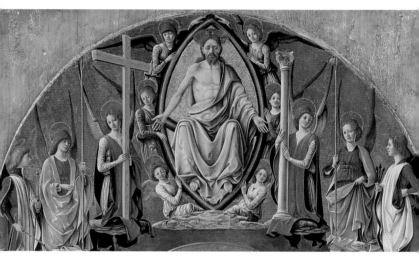

28. Detail of *Christ Glorified in the Court of Heaven*, by Fra Angelico, probably 1428–30.

29. Detail of *Saint Vincent Ferrer*, by Francesco del Cossa, probably about 1473–5.

Hardly any artists were as punctilious as Costa and Botticini in their depiction of the angelic orders, and even they, it must be admitted, do not engage closely with Dionysius's treatise. We are hard-pressed to distinguish nine separate choirs among the ranked angels glorifying Christ in Fra Angelico's predella panel, once part of the base of the high altar-piece in San Domenico, Fiesole [28]. Most painters understandably abbreviated the numbers of angels, and redistributed their prescribed colours for pictorial ends. The almond-shaped aureole surrounding Christ in Cossa's altarpiece of the Dominican Saint

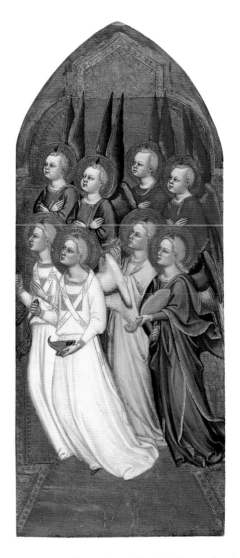

Vincent Ferrer is framed and flanked by multiples of three angels dressed in combinations of blues and reds, hinting at, more than illustrating, Dionysius's hierarchies [29].

On the whole it is the distinction between cherubim, seraphim and others which was most often observed by artists. The uppermost row of angels once flanking the Trinity at the top of Jacopo di Cione's complex polyptych altarpiece for San Pier Maggiore, Florence, now dismantled, represents love-red seraphim and wisdom-blue cherubim; the angels below wear white, pink and green [30]. Crivelli's God

30. Attributed to Jacopo di Cione and workshop, *Seraphim, Cherubim and Adoring Angels,* 1370–1.

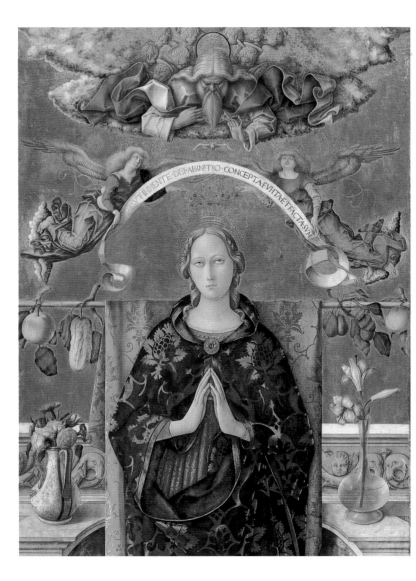

31. Detail of *The Immaculate Conception* by Carlo Crivelli, 1492.

the Father, supported in flight by disembodied infant seraphim and cherubim of appropriate hue, dispatches two adult angels in red, green and white to affirm the Immaculate Conception – the Virgin's conception 'from the beginning, in the mind of God' and her birth 'in the flesh' untainted by Original Sin [31].

Whether illustrated fully or only in part, Dionysius's *Celestial Hierarchies* determined the image of angels as heavenly courtiers, ranked according to their nearness to God's throne and their involvement in human affairs.

II ARCHANGELS

Michael

Not all courtiers are civilians. Michael, whose Hebrew name means 'who is like God?' is the commander-in-chief of the armies of the Lord of Hosts, and the earliest and most widely venerated of the archangels. He appears as the angelic protector of the Jewish people in the Book of Daniel, written between 167 and 164 BC during the persecution of the Jews by the conqueror of Jerusalem, the Syrian king Antiochus Epiphanes:

> And at that time shall Michael stand up, the great
> prince which standeth for the children of thy
> [Daniel's] people; and there shall be a time of
> trouble, such as never was since there was a
> nation… and at that time thy people shall be
> delivered… (Daniel 12:1)

In the late first-century Epistle of Jude, a Christian text, and in Revelation, the New Testament counterpart to the Book of Daniel, Michael is identified as victorious against the Devil:

> And there was war in heaven: Michael and his
> angels fought against the dragon; and the
> dragon fought and his angels,
> And prevailed not; neither was their place found
> any more in heaven.
> And the great dragon was cast out, that old
> serpent, called the Devil, and Satan, which
> deceiveth the whole world: he was cast out into
> the earth, and his angels were cast out with
> him. (Revelation 12:7–9)

Adopted by Christians as the saint protector of the Church Militant, Saint Michael is often depicted in warrior's dress. As early as the fourteenth century, Italian artists showed him in fanciful reconstructions of ancient Roman armour. This is how he appears in Spinello Aretino's fragment of Michael in battle at the head of his troops, illustrating the passage from Revelation [32]; in Fra Angelico's predella panel, where he glorifies Christ in Heaven [28, 33]; and in

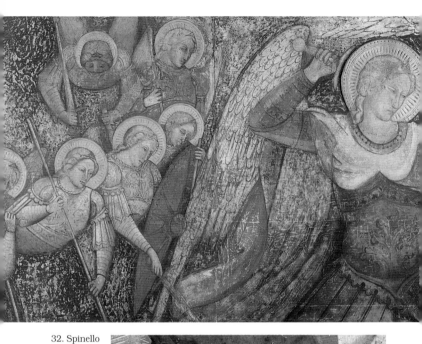

32. Spinello Aretino, *Saint Michael and Other Angels,* about 1373–1410.

33. Detail of *Christ Glorified in the Court of Heaven,* by Fra Angelico, probably 1428–30.

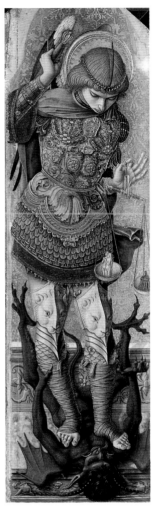
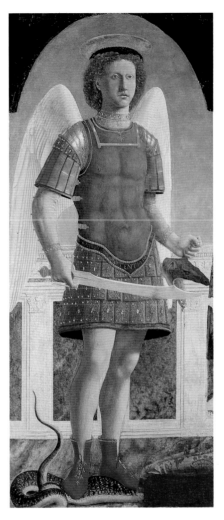

Crivelli's and Piero della Francesca's side panels from altarpieces [34, 35].

Crivelli portrays the archangel about to strike the Devil whom he has cast out of Heaven. Piero, unusually, shows him impassive after the final, victorious moment of the battle: Satan is not only being trampled, he has been slain and decapitated. Michael holds the devil-serpent's severed head by the ear – a proof that this is no common-or-garden snake. Crivelli's bejewelled knight displays his other identifying attribute, the scales, discussed below.

In all these representations the archangel is shown winged; Piero endows him with the beautiful white plumage of a swan. Were it not for his wings,

34. Carlo Crivelli, *Saint Michael*, about 1476.

35. Piero della Francesca, *Saint Michael*, completed 1469.

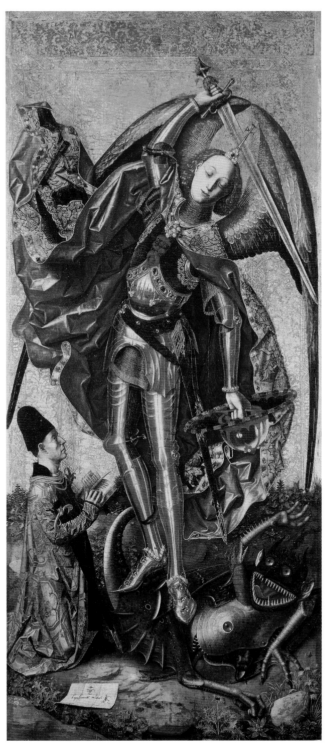

Michael might be mistaken for Saint George, that other dragon-slaying warrior of God. (The Latin word *draco* means both 'dragon' and 'serpent'.)

It would be difficult to take Bermejo's resplendent figure for anything but a celestial being [36]. His bird-of-paradise wings issue from the agitated folds of a mantle which is more priestly cope than military cloak. His plate armour is not made of steel but of gold; its convex breastplate mirrors the Gothic towers of the Heavenly Jerusalem. In his left hand he holds a crystal-domed shield. Suavely implacable, Michael swings his heavy sword at the demon, who screams and squirms beneath the angel's elegantly shod feet (37).

Antonio Juan, the noble donor of this great altarpiece for the church of San Miguel in Tous, kneels on the bare ground beside the Devil. He holds a psalter showing the opening lines of two penitential psalms: 'Have mercy upon me, O God, according to thy lovingkindness' (Psalm 51) and 'Out of the depths have I cried unto thee, O Lord' (Psalm 130).

The casting out of Satan from Heaven, as recounted in Revelation, had a particular resonance in fifteenth-century Catholic Spain: it was associated with the 'crusade' of the *reconquista*, the reconquering of territory from the 'infidel' Moors, who continued to rule Granada until 1492. But the choice of texts included in the painting also demonstrates its relevance to any individual soul. The earth is 'the depths' to which the Devil has been consigned, and it is from that sinful realm that the believer cries out for the mercy of God and the protection of Saint Michael.

36. Bartolomé Bermejo, *Saint Michael triumphant over the Devil with the Donor Anonio Juan*, about 1468.

37. Detail of 36.

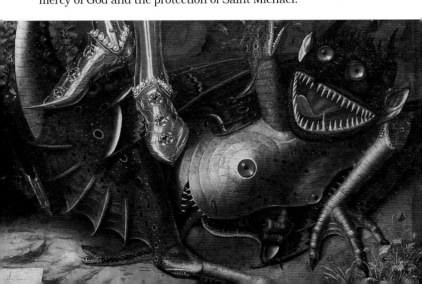

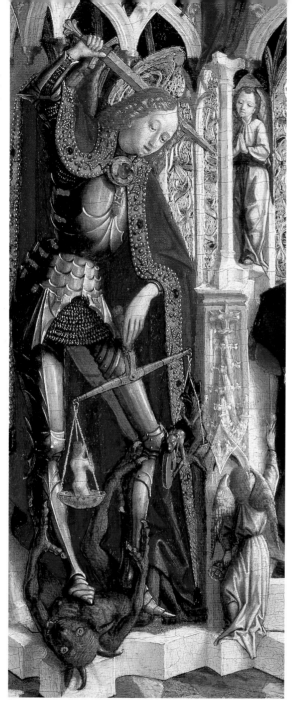

38. Michael Pacher, *The Virgin and Child Enthroned with Angels and Saints*, about 1475.

WEIGHER OF SOULS

Neither the Austrian Pacher [38] nor the Italian Perugino – whose Satan has unfortunately been cut off the bottom of the panel [39] – can match Bermejo's grandeur, though Perugino's reflective

steel-plate armour rivals the Spaniard's in subtlety of optical realism. Both these painters, however, like Crivelli, include scales or balances. Perugino's archangel, hands busied with shield and marshal's baton, rests his in the handy fork of an attendant tree stump [40]. Pacher's and Crivelli's both hold theirs in their left hand: they are weighing naked souls against demons, assessing their fitness for Heaven or for Hell.

39. Pietro Perugino, *The Archangel Michael* 1496–1500.

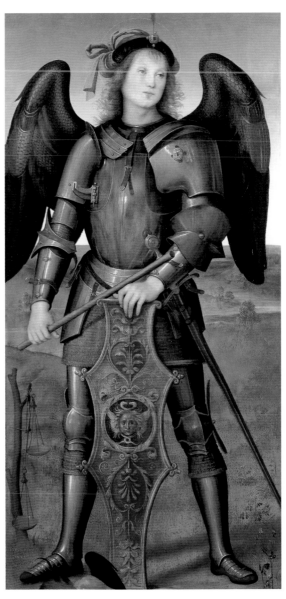

OPPPOSITE
41. Detail of
*Venus with Mercury and Cupid
'The School of Love'*
by Correggio, about 1525.

Michael's office as weigher of souls may have been inspired by the Epistle of Jude, where he is said to have argued with the Devil over the body of Moses (Jude, 9). But it is even more likely to have been inherited from ancient Graeco-Roman myth. Hermes (the Roman Mercury) is the herald or messenger of Zeus and of his brother Hades, towards whose underworld realm he guides the souls of the dead, weighing in a balance those of the ancient heroes. Although not winged himself, he wears winged sandals and a winged hat [41].

In early Christian imagery, so dependent on contemporary pagan art, these attributes of Mercury were sometimes given to Michael. The conflation of the two was compounded by churches dedicated to Saint Michael being erected on the hill-top sites of previous temples of Mercury.

The notion of weighing souls, inherited from pagan antiquity, would have been reinforced by a biblical text not originally connected with Michael, the prophet Daniel's warning to Belshazzar, King of Babylon: 'Thou art weighed in the balance, and art found wanting.' (Daniel 5:27)

Because of his funerary duties, Michael is traditionally identified with the angel assumed to be blowing the 'last trump', in Saint Paul's dramatic evocation of the general resurrection:

In a moment, in the twinkling of an eye, at the last trump: for the trumpet shall sound, and the dead shall be raised incorruptible, and we shall be changed.
(1 Corinthians 15:52)

In this last role, Michael is often a central figure in images of the Last Judgement – with a trumpet, but also often with his scales and sword.

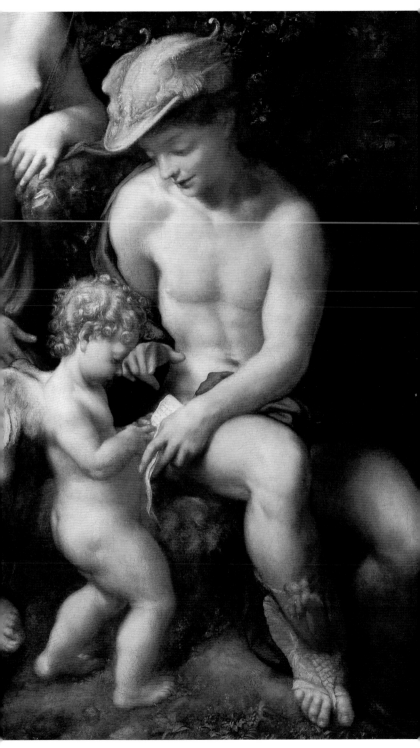

Gabriel

While Michael announces death, judgement and resurrection, Gabriel, whose Hebrew name means 'Man of God' or 'God is my strength', brings news of the end of iniquity, the return of the Jews from captivity and the coming of the kingdom of the saints. He is identified as the angel with the secret name who foretells the birth of Samson (Judges 13:3–21). Like Michael, he is first named in the Book of Daniel, where he interprets Daniel's visions (Daniel, 8:16; 9:21). In the New Testament, Gabriel announces the miraculous births of Saint John the Baptist (Luke 1:11–20), the precursor of Jesus, and of Jesus himself (Luke 1:26–38).

The fourteenth-century panel attributed to Niccolo di Pietro Gerini [42] is the only example in the Gallery of the Annunciation of Saint John's birth to Zacharias, the priest who, to his amazement, first becomes a father as 'an old man, and [his] wife well stricken in years'. The story is illustrated on this predella, or base, of an altarpiece dedicated to Saint John – the

42. Detail of *The Baptism of Christ*, attributed to Niccolo di Pietro Gerini, probably 1387.

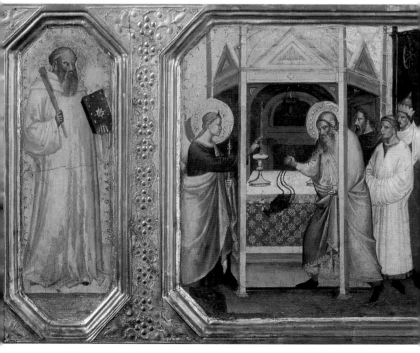

most significant episode in whose life, the Baptism of Christ, is the main subject of the altarpiece. In accordance with Luke's text, Zacharias is shown burning incense in the temple of the Lord, when 'there appeared unto him an angel of the Lord standing on the right side of the altar' (our left). With a film director's narrative fluidity, the painter 'pans' to show the birth of Saint John in Zacharias's house next door to the temple. Well-wishers bring food to John's mother Elizabeth, while midwives bathe the new-born baby.

Gabriel's Annunciation to Mary, signifying the Incarnation of God as man – central mystery of the Christian faith and the opening episode in the story of Salvation – is, as we would expect, much more frequently depicted in Christian art. It may appear as part of a cycle of the life of the Virgin or that of Christ, as the main image of an altarpiece, or with the Archangel and the Virgin in separate pictorial fields [62]. It was also often represented in sculpture.

A sermon on the Annunciation by the fifteenth-century Florentine friar Roberto Caracciolo alerts the modern viewer to traditional ways of analysing and

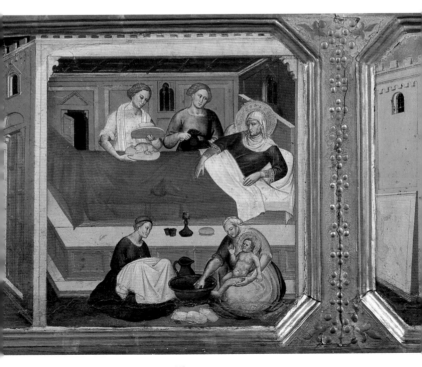

visualising the story told in Saint Luke's Gospel. Fra Roberto distinguished three principal mysteries within the main event: the Angelic Mission, the Angelic Salutation and the Angelic Colloquy (or, as we might say, the 'Dialogue between Gabriel and Mary'). Each of these is discussed in turn under five headings, derived in part from a close reading of scripture, but also influenced by long-established pictorial conventions. Fra Roberto, for example, explains that 'Nazareth' – the name of the town where the Angelic Mission took place (Luke 1:26) – signifies 'flower'. But the Hebrew word means 'twig, brushwood', and has always been connected by Christians, as the friar must have known, with the word 'branch' in one of the Old Testament prophecies thought to have foretold the birth of Christ: 'And there shall come forth a rod out of the stem of Jesse, and a Branch shall grow out of his roots' (Isaiah 11:1).

Nazareth was translated as 'flower' in the *Golden Legend*, an influential thirteenth-century anthology of saints' lives, but it may also have been suggested to Fra Roberto by the many paintings which locate the Annunciation in a walled garden [44] – the *hortus conclusus* symbolic of Mary's virginity and itself inspired by a biblical verse: 'A garden enclosed is my sister, my spouse' (Song of Songs, 4:12). Thus a Christ-centred interpretation (Nazareth = branch = Christ) was modified to a more picturesque Virgin-centred one, in which both flowery garden and flowers symbolise Mary, God's Mother and Bride.

Under the heading of the Angelic Colloquy, Fra Roberto describes the five successive 'Laudable Conditions of the Blessed Virgin' during the Annunciation: *conturbatio* or disquiet; *cogitatio* or reflection; *interrogatio* or inquiry; *humiliatio*, humility or submission; *meritatio* or merit. The last of these follows Gabriel's departure.

Even a cursory glance at pictures in the Gallery reveals that artists depicted the Virgin Annunciate in just such states of mind and spirit. In Duccio's fourteenth-century panel, from the predella of the principal altarpiece made for Siena Cathedral, she responds with the disquiet of *conturbatio* [43] nearly dropping the book in which, according to Saint Bernard, she had been reading the Old Testament prophecy concerning herself: 'Behold, a virgin shall

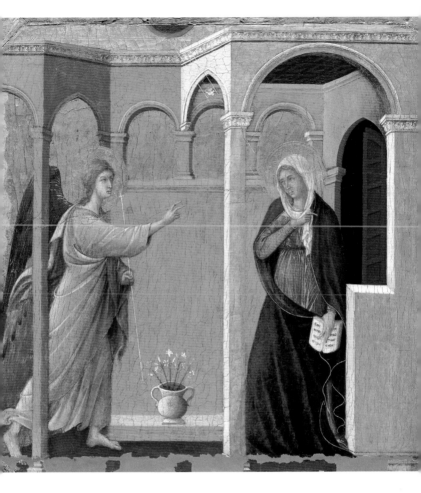

conceive, and bear a son, and shall call his name Immanuel [God with us]' (Isaiah 7:14). The Archangel, as Fra Roberto was to say, 'manifests itself to the corporeal vision of Mary' with peremptory suddenness:

43. Duccio,
The Annunciation,
1311.

> *Hail, thou that art highly favoured, the Lord is*
> *with thee; blessed art thou among women. And*
> *when she saw him, she was troubled at his*
> *saying, and cast in her mind what manner of*
> *salutation this should be.* (Luke 1:28–29)

The dove of the Holy Spirit flies into Mary's room through an archway, reminding us that Gabriel is only a herald or messenger. The Incarnation, although simultaneous with the Annunciation, is the work of God himself, acting through the third person of the Holy Trinity of Father, Son and Holy Spirit.

47

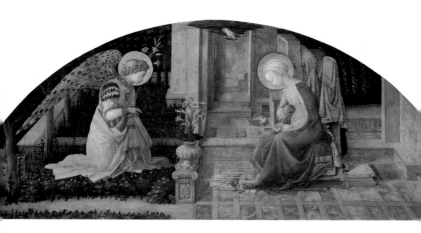

In Filippo Lippi's panel painted in the 1450s for the Medici family palace in Florence [44], Mary submits to the Annunciation in a state of *humiliatio*: 'Behold the handmaid of the Lord; be it unto me according to thy word.' (Luke 1:38). Gabriel does not stride into Mary's house; he salutes her from the garden in a pose of abasement almost the mirror image of hers. Fra Roberto would say that he 'honours the Virgin' by kneeling before her. The Holy Spirit, dispatched by the hand of God the Father, spirals downwards from Heaven towards a little opening in the front of her dress; rays of gold spurting out of it underline her active participation in God's plan.

The unknown German painter of a slightly later *Annunciation*, a panel from the dismembered altarpiece of the Benedictine Abbey at Liesborn [45], has dressed a wingless Gabriel in a priest's cope over his white angelic robe. Just such a costume might have been worn by an altar-boy actor impersonating the archangel in a 'miracle play' of the period, as performed in, or in front of, churches on 25 March, the feast day of the Annunciation. He carries a herald's staff, around which is wound a scroll bearing the Latin words of the Angelic Salutation:

'*Ave/ gracia/ plen[a] /dominus/ tecu[m]*'
'*Hail [Mary], full of grace, the Lord be with you.*'

In the absence of a depiction of the Holy Spirit, Gabriel points beyond his left shoulder, as if to say 'Another has sent me, I come from God.'

Mary receives the archangel in her bedchamber, itself symbolic of her relationship to Christ – the

48

'heavenly Bridegroom' (Matthew 9:15; 25:1; John 3:29), the 'Sun of Righteousness' (Malachi 4:2), who, like the sun which rises at dawn, 'is as a bridegroom coming out of his chamber' (Psalm 19:5). Her eyes are cast down, and her demeanour suggests *cogitatio*, reflection, as much as humility: 'How shall this be, seeing I know not a man?' (Luke 1: 34).

45. Master of Liesborn, *The Annunciation*, probably 1470–80.

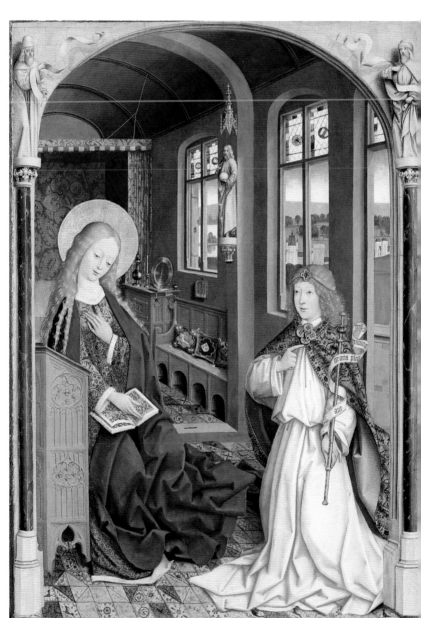

In 1486 Carlo Crivelli proudly signed his altar-piece for the church of the Virgin Annunciate in Ascoli Piceno [46]. The painting's unusual imagery refers to the papal edict which granted self-government to this little centre of the Italian Marches, news of which reached the citizens on 25 March 1482. Kneeling to salute the Virgin in the public setting of an idealised urban space, the archangel is accompanied by Ascoli's patron saint, the bishop-martyr Emidius, carrying a model of the city. From his extended wings and the fluttering of his ribbons, we can see that Gabriel has just alighted on the pavement. He holds a white lily or *fleur-de-lys*, his attribute through its association with the Virgin's purity. The Holy Spirit flies down from Heaven – divine counterpart of the caged homing pigeon in the background which delivered the Pope's message and of the birds fluttering about the dovecot. He enters the Virgin's chamber through an architect-designed aperture in the wall. A superb peacock, symbol of immortality because its flesh was thought to be imperishable, perches above the entrance.

Mary's pose recalls Fra Roberto's description of the Virgin's laudable condition of submission:

> *Lowering her head she spoke:*
> Behold the handmaid of the Lord.
> *She did not say 'Lady'; she did not say 'Queen'.*
> *Oh profound humility! oh extraordinary*
> *gentleness! 'Behold', she said, 'the slave and*
> *servant of my Lord.' And then, lifing her eyes to*
> *heaven, and bringing up her hands with her arms*
> *in the form of a cross, she ended as God, the*
> *Angels and the Holy Fathers desired:*
> Be it unto me according to thy word.[1]

Neither Fra Roberto Caracciolo nor any earlier artist, however, expressed the submission of the Virgin so profoundly as Poussin in his *Annunciation* of 1657 [47]. The solemnity of this painting is particularly apt, for it may have been intended for a sepulchral monument in Rome.

Cross-legged on a floor cushion, the Virgin no longer perceives the angel through her 'corporeal vision'; her eyes are closed, her head thrown back in ecstasy. Her pose simultaneously recalls the Madonna of Humility seated on the ground (the word 'humility'

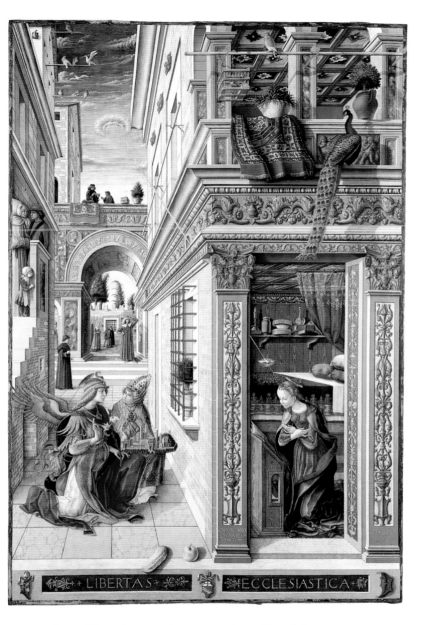

is derived from the Latin *humus*, 'earth, soil'), and the *orant*, a female figure often depicted in early Christian art, praying with outspread arms. Her mantle is, unusually, painted yellow. The aureoled dove, its shape recalling the cross, hovers majestically above her.

Devoid of all trappings but his powerful wings, the kneeling Archangel Gabriel gestures with both hands: the left pointing to Heaven, the right at the Virgin. His

46. Carlo Crivelli,
*The Annunciation,
with Saint Emidius,*
1486.

51

eyes are fixed on her, his lips parted in salutation –
but his 'speaking hands' are addressed to the viewer.
They invite us to meditate on the Virgin's acquies-
cence to the will of God; on the significance of the
Annunciation and the Incarnation in the story of
Salvation – the hope of mankind and of each individual
soul. But Poussin's solemn *Annunciation* can perhaps
best be read as a representation of the most popular
prayer of Catholic Europe, still repeated daily by
millions.

When Mary, pregnant with Jesus, went to visit
Elizabeth, pregnant with John the Baptist,

> *the babe leaped in [Elizabeth's] womb; and*
> *Elizabeth was filled with the Holy Ghost:*
> *And she spake out with a loud voice, and said,*
> *Blessed art thou among women, and blessed is*
> *the fruit of thy womb.* (Luke 1:41–42)

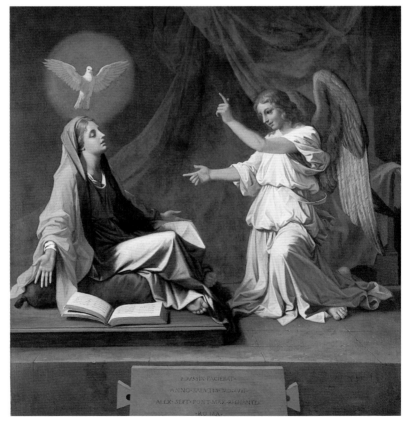

By the seventh century, Elizabeth's salutation had been combined with Gabriel's to form a short and easily remembered invocation to the Virgin Mary. To this 'angelic versicle' popularised among the laity by the Dominicans and Franciscans, there were added, in the sixteenth century, the words 'Holy Mary, Mother of God, Pray for us sinners, now and in the hour of our death' – a final plea to give the familiar prayer of the rosary:

48. Detail of 47.

> *Hail Mary, full of grace, the Lord is with thee.*
> *Blessed art thou among women, and blessed is*
> *the fruit of thy womb, Jesus. Holy Mary, Mother*
> *of God, pray for us sinners, now and at the hour*
> *of our death. Amen.*

Recalling this prayer, no imagery could have been more appropriate for a tomb. Poussin reminds us that God's princely messengers Michael and Gabriel, despite their seemingly different functions, bring equally momentous news from Heaven to Earth: news of our beginning and of our end.

Raphael

The least well-remembered of the three named archangels is Raphael, whose name means 'God has healed'. He appears in the Book of Tobit, composed, probably in Palestine, sometime around 200 BC. This touching 'Diaspora romance' – a story of Jewish exiles in Assyria – inspired by three secular folktales was intended to instil in its readers sound morals, faith in God and inhuman effort. Its protagonist and supposed author is Tobit, a virtuous old man who becomes blind and poor.

Tobit is supported in his affliction by his wife Anna, who undertakes 'women's work', spinning and weaving cloth for sale. Their exemplary family life and piety made them a favoured subject of Dutch seventeenth-century domestic pictures. Among the many artists attracted to the theme was the young Rembrandt [49]; the Latin verses appended to an engraving of this picture read:

> *Tobit meditates devoutly, beneath his shabby roof*
> *upon the vanity of human pleasure and the*
> *transitoriness of joy.*
> *Fate lets riches come and has them go.*
> *To you, O piety, be ever praise and honour.*

Rembrandt's subject, however, is narrative: the aged parents awaiting the return of their beloved son Tobias, whom Tobit has sent from Nineveh to Media to recover a debt from a kinsman. Thanks to Tobias's courage under the guidance of the Archangel Raphael, disguised as a distant relation, Azarias, Tobit will recover his sight and his fortune. Tobias will marry his kinsman's daughter, the virtuous and beautiful Sarah, having with Raphael's help exorcised the jealous demon who killed each of her previous seven bridegrooms. The family will be reunited and Tobit will live to a rich and fulfilled old age. But Rembrandt's couple don't yet know the outcome of Tobias's quest, nor even that he will return safely. They wait patiently by the half-open door, the anxious mother spinning, her blind husband turning his back to the sunlight he can no longer see.

Divine benevolence is both hidden and revealed through the archangel. He will shed his mortal disguise at the happy ending, after the piety and perseverance of the human characters have been tested to the full:

I am Raphael, one of the seven holy angels which
present the prayers of the saints, and which go in
and out before the glory of the Holy One.
Then they were both troubled, and fell upon their
faces: for they feared.
But he said unto them, Fear not, for it shall go well
with you; praise God therefore.
For not of any favour of mine, but by the will of our
God I came; wherefore praise him forever...
Now therefore give God thanks: for I go up to him
that sent me; but write all things which are done
in a book.
And when they arose, they saw him no more.
Then they confessed the great and wonderful
works of God, and how the angel of the Lord had
appeared unto them.

(Tobit, 12:15–22)

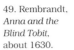

49. Rembrandt,
*Anna and the
Blind Tobit,*
about 1630.

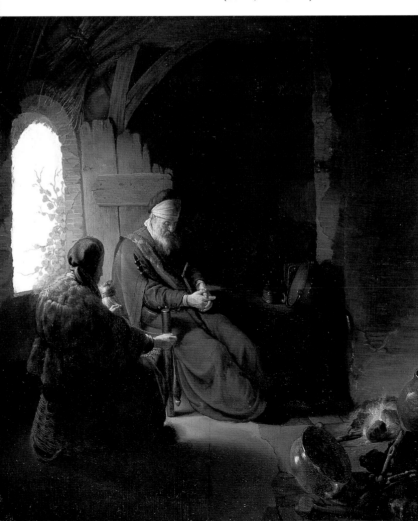

The earliest depictions of Raphael in the Collection come from Florence, where a religious confraternity dedicated to him, the Compagnia di Raffaello, was founded in 1409 by a charitable goldsmith to further religious instruction of the young. A painting of 1470–80, from Verrocchio's workshop [50], appears at first sight to be a straightforward depiction of Tobias's trip to Media to collect the silver owed to his father:

> So they went forth both, and the young man's dog with them... /And as they went on their journey, they came in the evening to the river Tigris, and they lodged there./And when the young man went down to wash himself, a fish leaped out of the river, and would have devoured him./ Then the angel said unto him, Take the fish. And the young man laid hold of the fish, and drew it to land./ To whom the angel said, Open the fish, and take the heart and the liver and the gall, and put them up safely./ So the young man did as the angel commanded him; and when they had roasted the fish, they did eat it: then they both went on their way, till they drew near to Ecbatane./ Then the young man said to the angel, ... to what use is the heart and the liver and the gall of the fish?/ And he said unto him, touching the heart and the liver, if a devil or an evil spirit trouble any, we must make a smoke thereof before the man or the woman, and the party shall be no more vexed./As for the gall, it is good to anoint a man that hath whiteness in his eyes, and he shall be healed.
>
> (Tobit 5:10; 6:1–8)

Tobias carries a scroll inscribed *Ricord*, for *ricordo*, a memorandum – his father's half of the contract with his kinsman, which he has given Tobias as a token of his identity. The golden box in Raphael's hand holds the fish's gall, heart and liver [51]. The colour of this box is significant; it points to another link between the Book of Tobit and the New Testament book of Revelation where, according to textual scholars, Raphael re-appears. On Tobias's and Sarah's wedding night, the heart and liver are burned to smoke out the fiend who killed her previous bridegrooms. In Revelation 8:3–5, a nameless angel appears before God's golden altar, 'having a golden censer', the smoke of whose incense 'ascended up before God'. When the

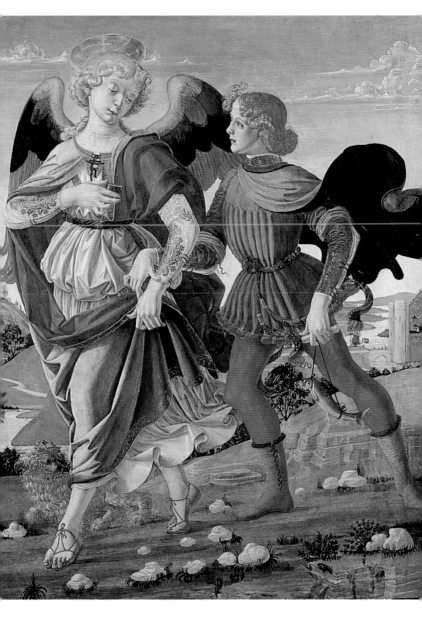

censer, filled with fire from the altar, is thrown down
upon the earth, it signals the beginning of the end
of the world: 'And the seven angels which had the
seven trumpets prepared themselves to sound.'
(Revelation 8:6.)

As we have seen, the seven angels of Revelation
were identified by Saint Paul with the seven arch-
angels of the Book of Tobit (page 28). Although the

50. Workshop of
Andrea del
Verrocchio, *Tobias
and the Angel*,
1470–80.

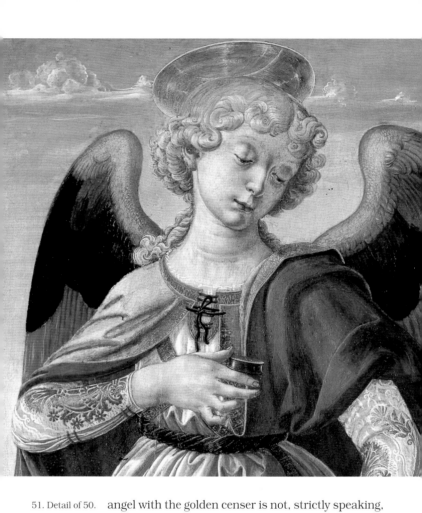

51. Detail of 50. angel with the golden censer is not, strictly speaking, one of the seven archangelic trumpeters, he appears at the same time, and is easily confused with them. In the tortuous logic of medieval interpretations of the Bible, the smoke of his incense is identified with the miraculous smoke of the fish's heart and liver burned, on Raphael's advice, upon a censer in Sarah's chamber – and the nameless angel with the golden censer becomes the Archangel Raphael, so Raphael's box holding the soon-to-be-burned offal must be golden too.

Although the boy and the angel in the picture seem to be discussing the 'curative properties' of the contents of the golden box as they walk, the painter's intention could not have been simply to illustrate this moment in the text. The art historian E. H. Gombrich explains:

> He [Verrocchio] knew perfectly well that the Bible
> described Raphael as travelling in the guise of a
> human companion… He could have no doubt that
> the fish which frightened young Tobias was of
> monstrous size and he certainly realised that the
> fish had been cut up and eaten – save the
> healthgiving entrails – by the time the two were
> proceeding on the road. Why, then, did he depart
> from the text? The answer is simple enough.
> The boy carries a fish because without this
> emblem we would not recognise him as Tobias.
> Azarias is painted with wings because without
> them we would not recognise him for an angel.
> And, finally, he is accompanied by Tobias,
> not because the painter meant to illustrate a
> particular moment in the story, but simply
> because without the young companion with the
> fish we would not recognise the angel as Raphael,
> the healer. Tobias, in fact, is Raphael's emblem.[2]

In other words, this is not a narrative painting but
a timeless devotional image of 'Saint' Raphael. The
rhymed Latin invocation inscribed on a similar panel
in a church in San Giovanni Valdarno makes clear
the purpose of such images: 'Raphael, health-giver
(*medicinalis*), be with me forever, and as thou wert
with Tobias, always be with me on my way.'

As Professor Gombrich emphasises, 'we must not
only think of physical healing and physical "ways"'.
When the hymns composed for the Feast Day of the
Archangel Raphael sing of 'our health's physician'
who should 'lead us safely back to our father' and let
the 'blind among the congregation see the light', they
are not merely alluding to Tobias's voyage and Tobit's
blindness, but to our journey through life, our spiritual
health and enlightenment. Thus understood, pictures
of the Archangel Raphael and the young Tobias,
popularised by the Compagnia di Raffaello in fifteenth-
century Florence, became prototypes of the later
imagery of the Guardian Angel and the human soul.

TRAVELLER

Not surprisingly, Tobias and the Archangel's event-
ful trip to Media was also associated with other
depictions of spiritual journeys. The two companions
may be found in the backgrounds of two late fifteenth-
century Florentine paintings in the Collection:

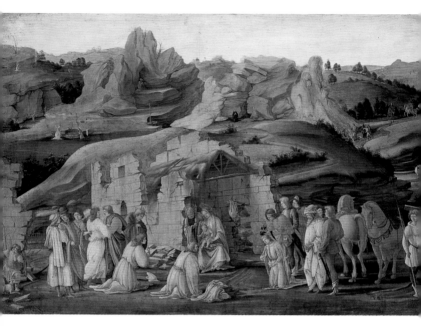

52. Filippino
Lippi,
*The Adoration of
the Kings,*
about 1480.

53. Detail of 52.

Filippino Lippi's *Adoration of the Kings* [52, 53] and
Lorenzo di Credi's *Virgin and Child* [54, 55].

The Three Kings had followed the star to the
ruined stable at Bethlehem, 'till it came and stood
over where the young child was' (Matthew 2:9), as
Filippino has depicted it. The vastness of the land-
scape through which they have travelled – their
retinue is still winding its way through the mountain
passes on the right – is accentuated by tiny figures of
hermits and penitents in the wilderness: Saint
Jerome adoring the crucifix, Saint Francis receiving
the stigmata, a female saint clothed only in her long

hair who could be either Mary Magdalene or Mary of Egypt, Saint Benedict. The diminutive figures of Raphael and Tobias are shown striding along a path in the distance [53]. The contemporaneous presence of saints from different centuries and places underlines not only the geographic extension, but also the timeless, spiritual and universal nature of the Kings' quest for the new-born Saviour, repeated yearly in the Church's liturgy, in miracle plays and festival processions.

Lorenzo di Credi, a pupil of Verrocchio, places the Virgin and Child in front of an arcade opening onto an extensive view [54]. Tobias, the dog and the Archangel advance towards them down a tree-lined avenue [55], in much the same poses as in the devotional panel of which they are the main subject and which originated from the same workshop [50].

54. Lorenzo di Credi, *The Virgin and Child*, 1480–1500.

55. Detail of 54.

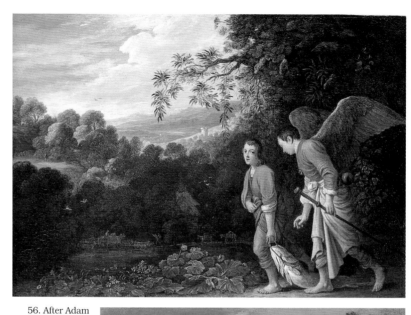

56. After Adam Elsheimer, *Tobias and the Archangel Raphael returning with the Fish,* mid-17th century.

57. Domenichino, *Landscape with Tobias laying hold of the Fish,* about 1610–13.

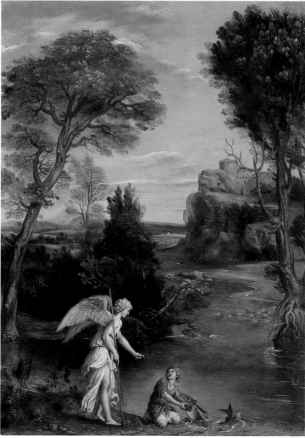

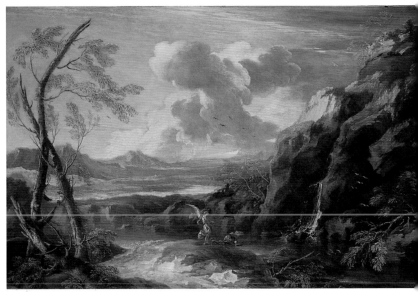

Emblematic travellers, Tobias and Raphael are gradually reduced to mere accessories of landscape, barely giving added significance to an essentially secular, decorative seventeenth-century genre, as in this copy (after an engraving) of a now-lost work by Elsheimer [56]. They often appear beside a river or pond: Raphael commands Tobias to catch the fish in the foreground of many landscape paintings [57, 58]; others show them fording the Tigris before the attack by the fish [59].

58. Salvator Rosa,
*Landscape
with Tobias
and the Angel,*
probably 1660–73.

59. Jan Lievens,
*A Landscape with
Tobias and the
Angel,* 1640–4.

The Three Archangels reunited

Perugino's more static late fifteenth-century depiction of Raphael [60] recalls both the aptness of Gombrich's analysis and the Archangel's own status. Along with Perugino's resolute Michael [39], it once formed part of a six-panelled altarpiece in Pavia,

60. Pietro Perugino, *The Archangel Raphael with Tobias*, about 1496–1500.

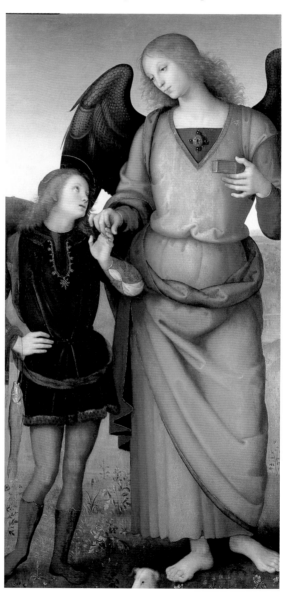

dismembered sometime between 1784 and 1856. Individual panels were then cut down, resulting in the loss of most of Tobias's dog and Michael's vanquished devil. The original appearance of the whole is known, however, through copies of the dispersed scenes reintegrated with an original panel remaining in Pavia. Michael and Raphael stood on either side of the central panel of the Virgin adoring the Christ Child, as they do now in the National Gallery. Above them, an image of God the Father, also by Perugino, was flanked by a Virgin Annunciate and an Archangel Gabriel by another painter.

Less neatly, a similar arrangement appears in an earlier altarpiece depicting *The Ascension of Saint John the Evangelist, with Saints*, shown in its entirety in the Gallery [61]. The Trinity has pride of place on

61. Giovanni del Ponte, *The Ascension of Saint John the Evangelist, with Saints*, probably about 1410–20.

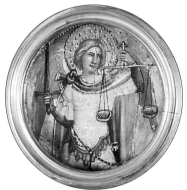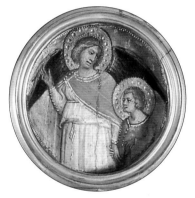

62–5.
Details of 61.
the central pinnacle; the left and right pinnacles depict Gabriel [62] and the Virgin Annunciate [63]. Small roundels above the side panels of the main tier show Michael on the left [64], Raphael with Tobias on the right [65].

In works such as these, it is not really the stories of the three archangels which are shown: the Virgin Annunciate is an emblem or attribute of Gabriel, as Tobias is of Raphael and Satan is of Michael. In other words, the painters who designed similar schemes represented the main protagonists in the story of Salvation – God the Father, the Holy Trinity, the Virgin and Child – framed by the three archangels named in the Bible: courtiers before the throne of God and his emissaries to mankind, charged with our welfare from beginning to end, from birth to death and resurrection – Gabriel, Raphael and Michael.

III GUARDIAN ANGELS

At the same time came the disciples unto Jesus,
saying, Who is the greatest in the kingdom of
heaven?
And Jesus called a little child unto him, and set
him in the midst of them,
And said, Verily I say unto you, Except ye be con-
verted, and become as little children, ye shall not
enter into the kingdom of heaven.
Whosoever therefore shall humble himself as this
little child, the same is greatest in the kingdom of
heaven...Take heed that ye despise not one of
these little ones; for I say unto you, That in heaven
their angels do always behold the face of my
Father which is in heaven.

(Matthew 18:1–10)

In the Old Testament, every nation has its own angel; Michael, as we have seen, is the angel-protector of Israel (Daniel 12:1). People in trouble are comforted or counselled by angels, like the one who appeared to Hagar when she and her son Ishmael were dying of thirst in the wilderness, and showed her 'a well of water' (Genesis 21:17–18) [66]. Some of the ancient scrolls discovered near the Dead Sea speak of

66. Guercino, *The Angel appearing to Hagar and Ishmael*, 1652–3.

spirits watching over individuals – at times two, one of truth and the other of unrighteousness. But the passage quoted above from the Gospel of Matthew is the first hint, in a scriptural text, of an angel in heaven permanently dedicated to every soul on earth: the 'little ones' have 'their angels [who] do always behold the face' of God.

The Acts of the Apostles elaborated this notion, testifying to the popular belief that people's own angels resemble them. Thrown into prison by Herod, the apostle Peter was miraculously delivered (by an angel, who is not, however, relevant in this context). He went to take refuge in the house of Mary the mother of John, 'where many were gathered together praying'. A woman named Rhoda recognised his voice at the door, but when she ran to tell the others that he was there, they could not believe it, saying 'It is his angel' (Acts 12:15).

Out of these slender shreds of 'evidence', combined with the stories of the archangels and especially the tale of Tobias and Raphael, was born the notion of the guardian angel. It was nourished in the cloister by medieval mystics such as Saint Bernard. From the sixteenth century onwards it was propagated among the laity, most vigorously by the Society of Jesus founded in 1534. As Protestant reformers began to attack the cult of angels, so the Catholic position hardened. Successive popes instituted feast days 'angelorum custodum nostrorum', 'of our guardian angels', obligatory in some territories but not others; by 1670 the celebration had been extended to the entire Church.

Many seventeenth- and eighteenth-century Roman Catholic altarpieces are dedicated to the Guardian Angel. The majority resemble the devotional images of Raphael and Tobias striding through the countryside, merely omitting their specific attributes of dog, fish and fish's innards. The human soul had sometimes been depicted in death scenes as a child, taken up to Heaven not in its adult form [3] but as a swaddled or naked baby [67]. The convention of showing it as a child with its guardian angel also alludes to the 'little ones' in the text from Matthew already noted, and reflects the advice of a sixteenth-century Jesuit, Father Jerome Nadal, to follow the guidance of one's guardian angel 'as a timid child, trembling and weak, entrusts itself to a magnanimous giant.'

Perhaps because no outstanding painting of this type was available when the bulk of the Collection was being amassed, or perhaps because of Protestant bias, the National Gallery does not house a single conventional image of the soul with its guardian angel. The omission is made up, however, by a masterpiece: Velázquez's *Christ after the Flagellation contemplated by the Christian Soul* [68].

The rare subject of this painting – a guardian angel exhorting the human soul to contemplate the sufferings of Christ – seems to be peculiar to Spain, and had been forgotten by the time the picture was presented to the Gallery in 1883. A letter written the following year to the donor, John Savile Lumley, by his friend Lord Napier gives an intriguing glimpse of Victorian attitudes:

> We were a couple of days in London on our way here, and I took my wife to see the picture... When we went to the picture there was an old woman of the better lower class looking at it who said to Lady Napier spontaneously with a very moving expression 'Look at his poor hands – they are strangled' and then 'that is his child.' She did not

67. Detail of *The Crucifixion*, attributed to Jacopo di Cione, about 1368–70.

68. Diego
Velázquez,
*Christ after the
Flagellation
contemplated by
the Christian Soul*,
probably 1628–9.

69. Detail of 68.

*understand it was Jesus. She apparently thought
it was some helpless innocent martyr (or perhaps
even malefactor) and that his child was being
brought out to him to take leave of him or soothe
his sufferings. I observed that when we looked
fixedly at the picture a number of the humbler sort
of people flocked to it and seemed to survey it
with deep interest but probably they had no
conception of the real intent of the artist or of the
mystic meaning.*[3]

Despite his patronising tone, Lord Napier himself
may not have fully understood 'the mystic meaning' of
the picture. Its precise significance was published only
in 1905, and as late as 1908, a young people's guide
to the National Gallery, although correctly identifying
both Jesus and the guardian angel, still speaks of 'the
little child', even referring to 'the fair-haired little one' –
the author's error probably conditioned by the
Edwardian stereotype of blond and curly-haired
infant piety [69].

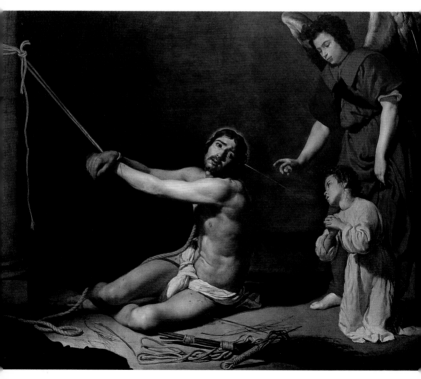

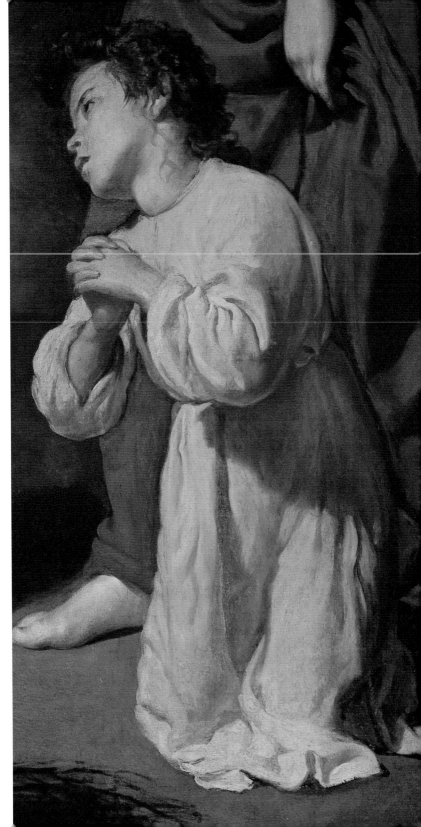

But Velázquez, being a seventeenth-century Spaniard and working for Catholic patrons, did not automatically assume that angels only guarded little children – and he certainly did not intend the 'child' to appear sweetly endearing. A similar picture by the Sevillan painter Juan de Roelas is inscribed: 'Soul, have pity on me – for you have reduced me to this state'.

The inscription, and the paintings themselves, have been related to a Franciscan handbook written at the end of the thirteenth century and widely circulated ever since: the *Meditations on the Life of Christ*. It exhorts the reader to contemplate the vividly described events of Christ's life – including the Flagellation:

> *The Lord is therefore stripped and bound to a column and scourged in various ways. He stands naked before them all, in youthful grace and shamefacedness, beautiful in form above the sons of men, and sustains the harsh and grievous scourges on His innocent, tender, pure and lovely flesh… O Lord Jesus!… Your love and our sin made you feeble. Cursed be such sin, for which you are so afflicted!* [4]

Rather than basing his picture on this medieval text, however, Velàzquez is more likely to have been inspired by a contemporary devotional practice indebted to it. The guardian angel leads the timid child-like soul through a meditation of the kind enjoined by Saint Ignatius Loyola (d.1556), the Spanish founder of the Society of Jesus, in his *Spiritual Exercises for the Overcoming of Self and the Regulation of One's Life on the Basis of a Decision arrived at without any Unregulated Motive*. The essential first step of these exercises is the contemplation of sin – sin which has made necessary redemption through Christ's sacrifice:

If I am contemplating ... the Passion, I will ask for
suffering, grief and agony, in the company of
Christ in agony.
Here my prayer will be that I may feel wholly
ashamed of myself, thinking how often I have
deserved eternal damnation for my frequent sins,
whilst many have been lost for a single sin ... By
an effort of my memory, I will recall the first sin,
that of the angels ... I compare my numerous sins
with the angels' one sin: that one sin brought
them to Hell: how often have I deserved it for all
my sins.
The memory's part is to recall how the angels were
created in grace, but refused to make the most of
their free will in honouring and obeying their
Creator and Lord: they fell victims to pride, and
their state of grace was perverted to one of evil
will, as they were plunged from Heaven into Hell.
Using my reason in the same way, I will think
about all this in greater detail: by my will I try to
evoke the proper sentiments.

Later, through systematic contemplation and
prayer, the soul is taught to 'achieve love' in Christ:

Realise that all gifts and benefits come from
above. My moderate ability comes from the supreme
Omnipotence on high, as do my sense of justice,
kindliness, charity, mercy, and so on, like sun-
beams from the sun or streams from their source.[5]

I do not mean to suggest that Velázquez was liter-
ally illustrating the *Spiritual Exercises*, but that his
religious paintings, and this one above all, were
grounded in the same modes of thought and feeling.
For, as the angel leads the soul, like 'a timid child,
trembling and weak', to contemplate Christ after the
Flagellation, so the painter leads viewers to meditate
both on Christ's sufferings and on the state of their
own souls. As much as Christ himself, the soul
and the guardian angel both become objects of our
contemplation.

Ignatius urges the imaginative use of all our
senses during the *Spiritual Exercises*, so that we
may *see, hear, smell, taste* and even seem to *touch* the
events of Christ's life or, for instance, the battle
between the forces of good and of evil. Velázquez, I

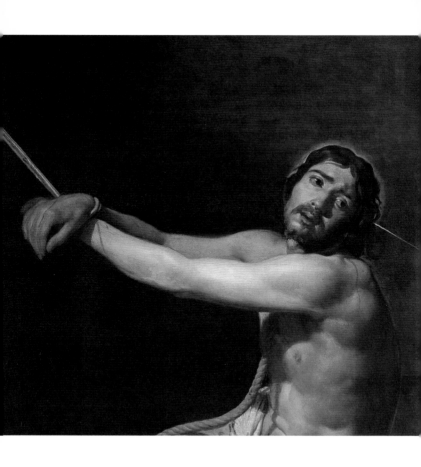

71. Detail of 68.

believe, relies on pictorial realism to similar ends. In this reading the painted beam of light issuing from Christ's aureole to strike the heart of the penitent soul is the visible counterpart of Ignatius's metaphoric sunbeams, symbols of God's gifts and benefits. We are almost invited to touch the makeshift, blood-stained whips and scourges at the edge of the canvas. With Lord Napier's 'old woman of the better lower class' we feel Christ's 'poor hands' being 'strangled' by the ropes [71]. His body may be idealised, but it is nonetheless a real body, drawn, like his face, from life. The face itself, full and round, with a stubby beard and moustache, barely resembles the traditional, attenuated 'true likeness' of Christ derived from centuries-old Syrian icons.

And that is why, I think, the angel wears pageantry wings attached by bands criss-crossing its russet robe [72]. The model, who resembles an earnest

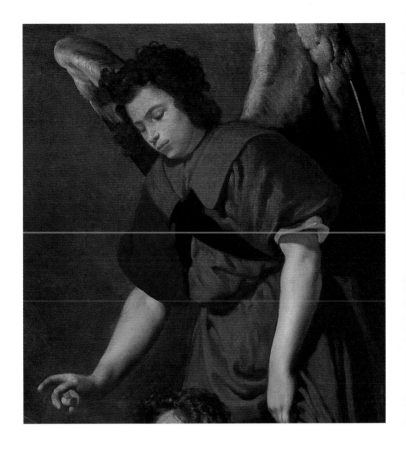

seminarian, might have been a youthful assistant, or perhaps a young woman employed about the house – viewers have perceived it as both male and female. It is neither ethereal nor descended down to earth on billowing clouds, bathed in celestial radiance, but stands in a bare, stage-like space – a space which is nowhere and everywhere, wherever and whenever Christ is made to suffer. It is all the more real for being a pretend angel, like the ones in processions, miracle plays or our own school plays. Even the dullest soul can imagine such an angel.

The soul itself – a boy posed too long for comfort on his knees, with his head cocked at an awkward angle – is really too old to be wearing a christening robe [69]. But the point of that innocent white robe, which would not have been lost on the painter's contemporaries, is that it also served as a burial shroud if the child died in infancy.

72. Detail of 68.

'In my beginning is my end', wrote T.S. Eliot in 1940, echoing in reverse the motto of the Catholic Mary Queen of Scots: 'In my end is my beginning'.

Through his painted exercise in religious meditation, Velázquez, a painter whose spirituality was as down-to-earth as Ignatius's own, also guides our thoughts from our beginning to our end, or spiritual rebirth.

In Christian thought, angels not only mediate between God and ourselves: they are also the clearest link between the Old and New Testaments, a token of the origins of Christianity in Judaism. Anonymous angels announce, foretell, comfort and liberate holy persons in the Gospels as they did in the Hebrew Bible. The archangels Michael and Gabriel, first named in the Book of Daniel, and Raphael from the Book of Tobit, reappear in Luke, in Jude and in Revelation. Saint Paul's angelology is based on Jewish lore. Since this in turn was influenced by the religion and folk beliefs of the Jews' polytheistic neighbours, angels also link the Judaeo-Christian tradition to the pagan world – a connection reinforced by Christian art, with its borrowings from Graeco-Roman imagery.

Pictorial angels, as we have seen, express the medieval elevation of the Virgin Mary to a status nearly equal to that of God [10, 16]. They could also ease the migration of religious imagery from public to private sphere, from distant to close viewing.

The sight of a realistic dead man's head on a plate would turn most stomachs. Surrounded by gracefully fluttering angels, Mostaert's image of the decapitated John the Baptist, isolated from the story of his execution, becomes an acceptable, almost decorative object of personal devotion [73]. The angel in red demonstrates the head's status as a sacred relic, while the others exemplify what our reactions to it should be: not revulsion but different stages of lamentation, pity (one of the naked *putti* closes John's eyes) compassion and grief. The crosses adorning the angels' dresses recall the so-called Maltese cross, emblem of the Order of the Hospitallers of Saint John of Jerusalem, founded in the eleventh century in honour of the Baptist – suggesting that the picture was painted for a knight of the Order in Mostaert's native Haarlem.

74. Detail of
*Christ Glorified in
the Court of
Heaven,*
by Fra Angelico,
probably 1428–30.

Velázquez's great painting, and Mostaert's modest one, summarise for us the role of angels in Christian art: they teach us what to think and feel, and how to behave. Not every viewer can successfully emulate the fortitude of martyrs or the self-sacrifice of Christ, but we can all aspire to imitate angels. And by showing us how angels look, and what angels see, painters have enabled us to imagine the invisible, that mysterious realm the other side of birth and death.

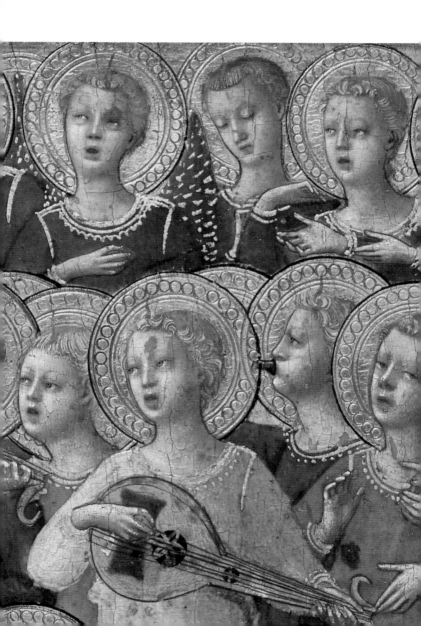

NOTES

1. Quoted in Michael Baxandall, *Painting and Experience in Fifteenth-Century Italy*, Oxford, 1972, p. 55

2. E.H. Gombrich, 'Tobias and the Angel', *Symbolic Images*, London, 1972, p.28

3. Letter held in Nottinghamshire Archives Office

4. *Meditations on the Life of Christ – an illustrated manuscript of the Fourteenth Century*, transl. by Isa Ragusa, ed. Isa Ragusa and Rosalie B. Green, Princeton, 1961, p.328.

5. *The Spiritual Exercises of St Ignatius Loyola*, transl. by Thomas Corbishley, S.J., Chichester, 1979, pp.31, 80

6. *The Spiritual Exercises of St Ignatius Loyola* p. 65

FURTHER READING

A great deal has been published on angels, from Dionysius the Pseudo-Areopagite's *On the Celestial Hierarchies* to picture books and entries in scholarly encyclopedias such as the following:

The Encyclopedia of Biblical Theology, ed. Johannes B. Bauer, Shed and Ward, London, 1970.

The Catholic Encyclopedia, ed. Charles G. Hebermann, 17 vols, Encyclopedia Press, New York, 1907-1918.

Dictionnaire de la spiritualité ascetique et mystique: doctrine et histoire, ed. Marcel Villier S.J. et al, Beauchesne et ses fils, Paris, 1937-.

MORE READILY AVAILABLE OUTSIDE SPECIALIST LIBRARIES ARE:

The Oxford Companion to the Bible, ed. Bruce M. Metzger and Michael D. Coogan,
Oxford University Press, New York/Oxford, 1993.

The New Jerusalem Bible, ed. Henry Wansbrought and others, Darton, Longman & Todd, London, 1985.

ON INDIVIDUAL THEMES OR PAINTINGS:

The National Gallery Schools Catalogues

Michael Baxandall, *Painting and Experience in Fifteenth-Century Italy*,
Clarendon Press, Oxford, 1972, repr. 1988.

E.H. Gombrich, 'Tobias and the Angel' in *Symbolic Images, Studies in the Art of the Renaissance*,
Phaidon Press, London, 1972.